W9-BKV-967

EDUCATION

LIBRARY

QUEEN'S UNIVERSITY
AT KINGSTON

KINGSTON ONTARIO CANADA

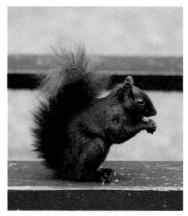

Busy,
Busy
Squirrels

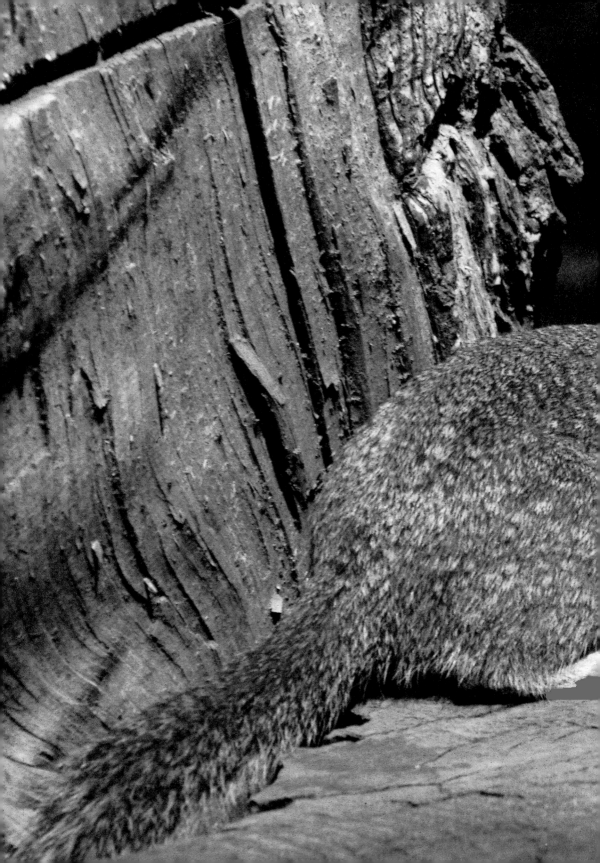

Busy, Busy Squirrels

Colleen Stanley Bare
Photographs by the author

Cobblehill Books/Dutton
New York

Juv. QL737.R68B34 1991

To Mildred and Jim

Copyright © 1991 by Colleen Stanley Bare
All rights reserved. No part of this book may be reproduced
in any form without permission in writing from the publisher.

Library of Congress Cataloging-in-Publication Data

Bare, Colleen Stanley.
 Busy, busy squirrels / Colleen Stanley Bare ; photographs
by the author.
 p. cm.
Includes index.
 Summary: Discusses the various kinds of squirrels and
their life cycles.
ISBN 0-525-65063-6
1. Squirrels—Juvenile literature. 2. Sciuridae—Juvenile
literature. [1. Squirrels.] I. Title.
QL737.R68B34 1991
599.32'32—dc20 90-44219 CIP AC

Published in the United States by Cobblehill Books,
 an affiliate of Dutton Children's Books,
 a division of Penguin Books USA Inc.

Designed by Charlotte Staub
Printed in Hong Kong First Edition
10 9 8 7 6 5 4 3 2

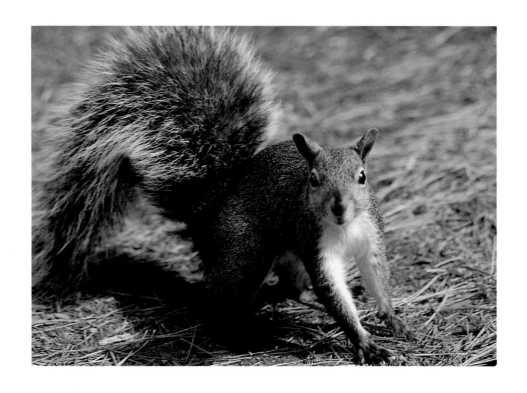

Squirrels are furry, bright, lively little animals that are very busy.

Squirrels begin being busy in early morning. They leave their nests and burrows to start searching for food.

Quietly they hunt for their favorite nuts and acorns, seeds, plants, blossoms, grasses, and insects.

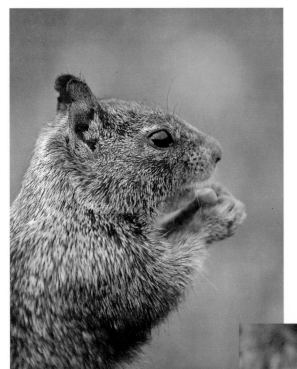

Seeds

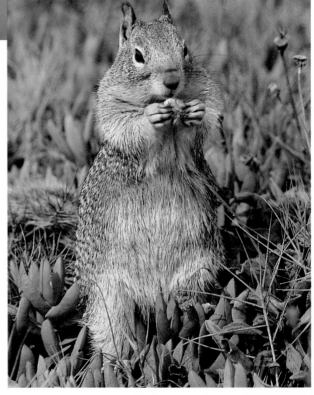

6

Blossoms

Squirrels live on all continents of the world, except Australia and Antarctica.

America has millions of squirrels, in almost every region of every state.

They are found from high mountains to seashores, in forests, fields, deserts, and meadows, by roads, rivers, canals, and streams.

Squirrel at the seashore

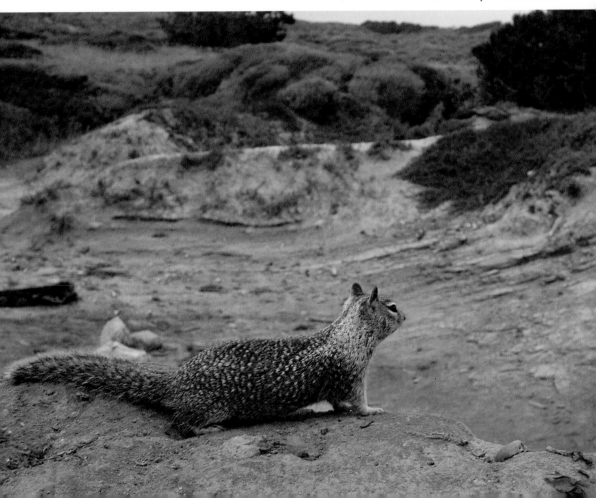

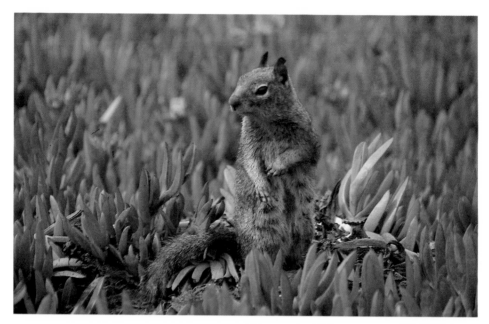

Squirrel in a field

Wherever you live, squirrels are probably nearby.

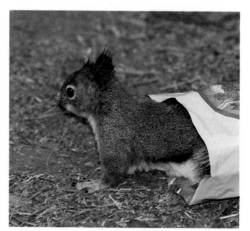

Squirrel in a park, stealing potato chips

Squirrels that Live in the Trees

The most common squirrels are those that live in trees. And the most common tree squirrels are gray squirrels.

Gray squirrel

Tree squirrel

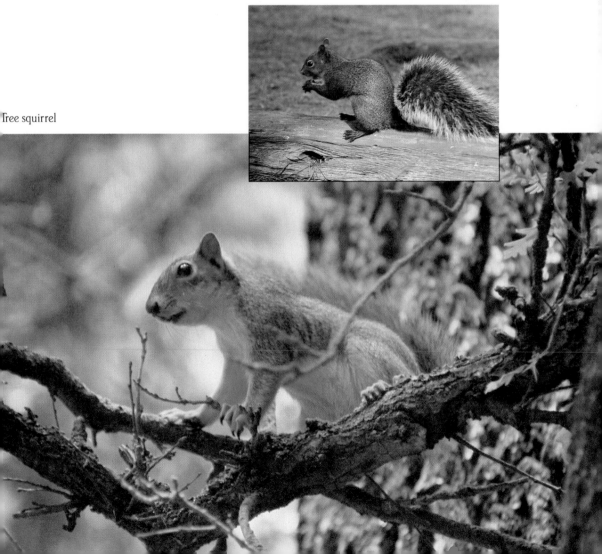

Fox squirrel

Chickaree

The largest tree squirrels are named fox squirrels. They are two feet long, weighing two to three pounds.

The tiniest tree squirrels are the red squirrels, nicknamed chickarees. Chickarees are a foot long and weigh half a pound.
They are also the noisiest tree squirrels and scold, squawk, and sputter at other squirrels and at humans.

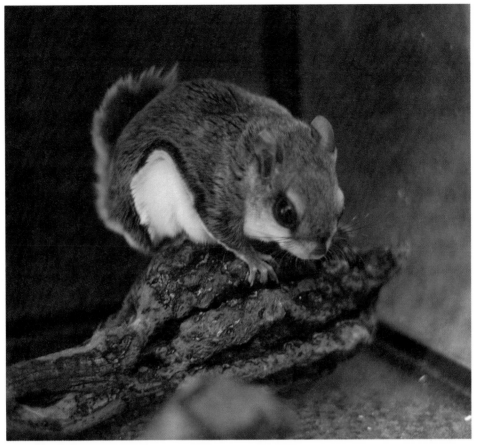
Flying squirrel

One tree squirrel is called a flying squirrel.
Flying squirrels glide from tree to tree,
instead of jumping like other squirrels.
They are the only *nocturnal* squirrels.
That means they stay awake at night and
sleep in the daytime.

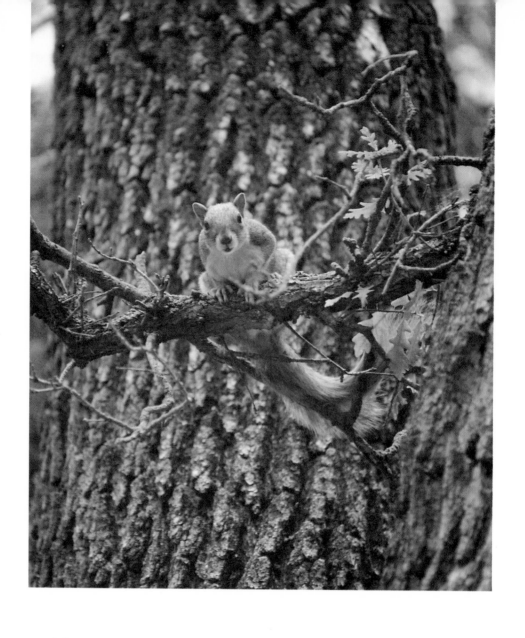

Tree squirrels spend most of their lives in trees. They race along branches, leap from tree to tree, and go up and down, down and up, the tree trunks.

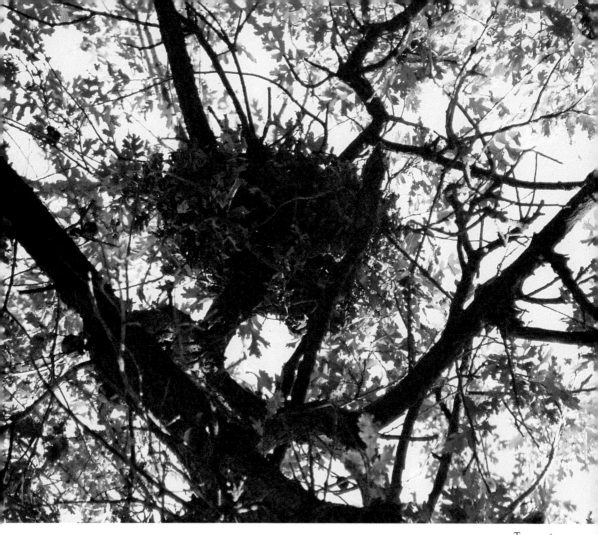

Tree nest

Tree squirrels build nests in tree trunk holes or high up in the branches.

Here they sleep, stay out of bad weather, and raise their young.

Tree squirrels are active all winter and do not *hibernate* — take a deep sleep.

Squirrels that Live in the Ground

Many squirrels live in burrows under the ground instead of in the trees.

They look a lot like tree squirrels, except their tails are often smaller and less furry.

Some variety of ground-dwelling squirrel is found almost everywhere.

Ground squirrel

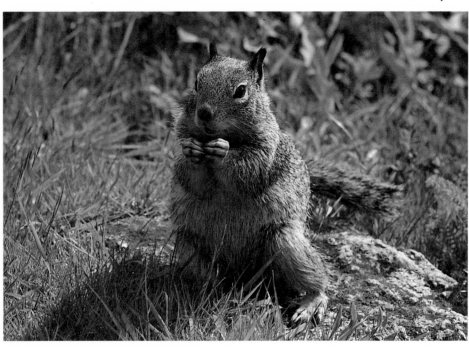

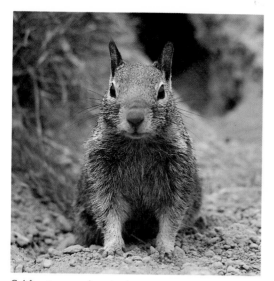
California ground squirrel

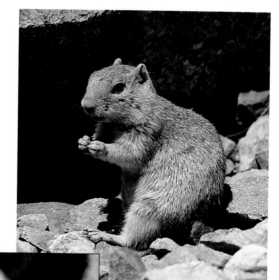
Belding ground squirrel

Golden-mantled ground squirrel

Many have "ground squirrel" as part of their names, such as the California, Washington, Idaho, Belding, and Golden-mantled ground squirrels.

15

Other squirrels that live in the ground are named chipmunks, prairie dogs, woodchucks, and marmots.

Chipmunks are among the smallest of the ground-type squirrels, some weighing only an ounce or two. They always have stripes on their faces and their sides.

Chipmunk

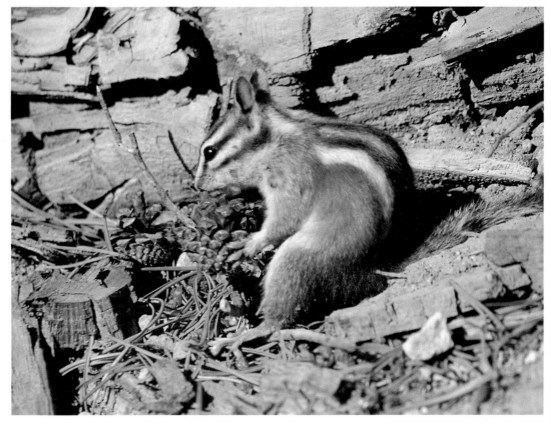

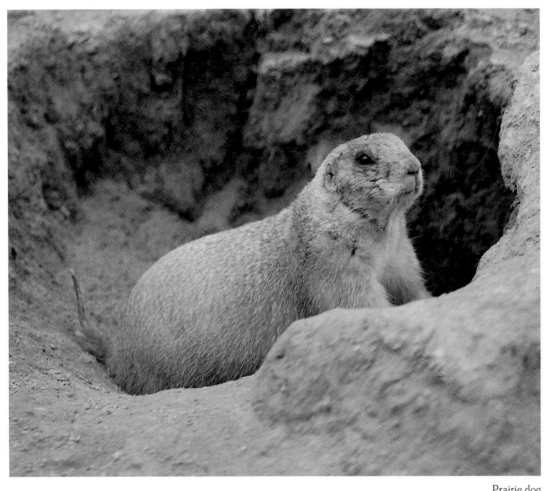

Prairie dog

Prairie dogs aren't dogs at all.
They don't look like dogs, they don't act like dogs, because they really are squirrels.
They live in large groups called prairie dog towns and dig big burrows in the ground.

17

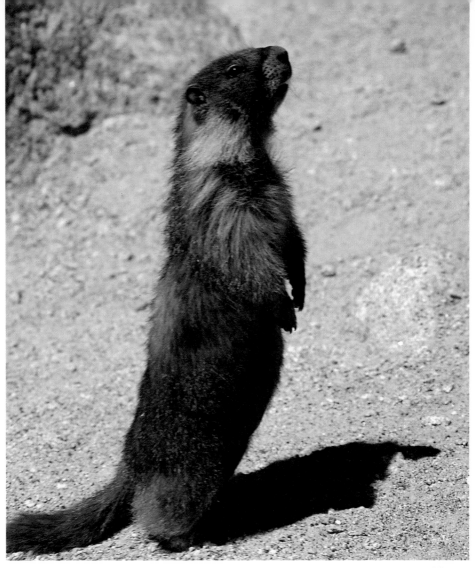
Marmot

Members of the marmot family are the biggest ground-dwelling squirrels. Some are catsize—up to two feet and ten pounds. This group consists of the woodchucks (also called groundhogs) and the marmots.

In the warm months, squirrels that live underground spend time digging and enlarging their burrows. Some burrows are very long with many openings.

In the cold months, these squirrels stay in their burrows and take a long deep sleep (hibernate). Once in awhile they awaken to eat stored nuts and seeds.

This recently remodeled burrow has nine entrances.

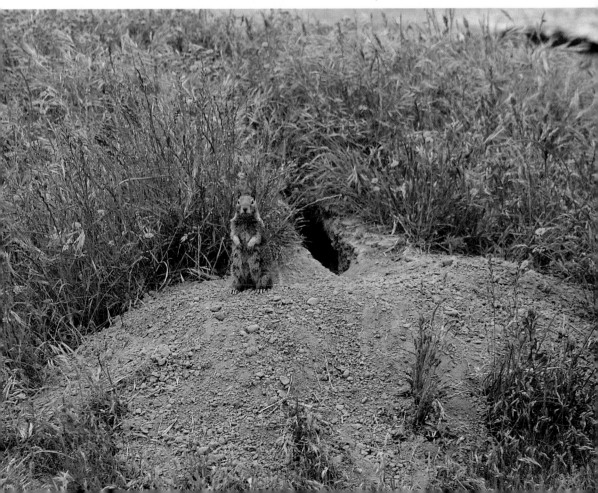

All Squirrels Have Much in Common

Squirrels are rodents like mice, rats, and hamsters.

All rodents have four incisor teeth that keep growing and must be ground off by gnawing on hard objects like nuts.

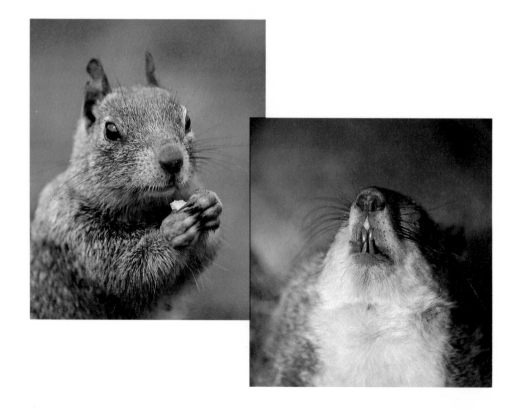

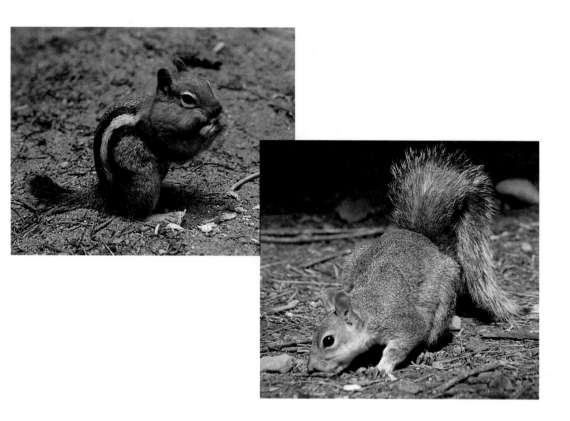

Squirrels store food.

Ground squirrels and chipmunks carry it in pouches inside their cheeks, back to their burrows for storage.

Tree squirrels bury nuts and seeds in the ground, for later eating. Their keen sense of smell helps them find the buried food.

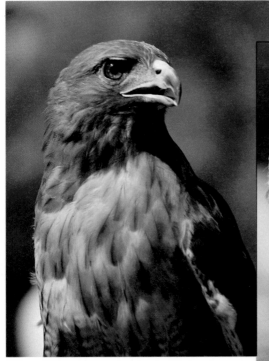
Red-tailed hawk

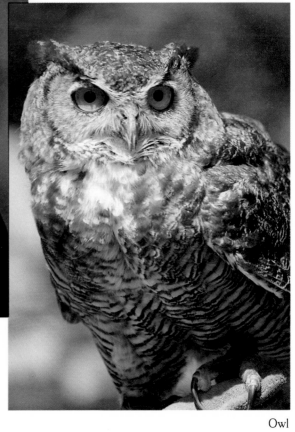
Owl

Squirrels can be very noisy. They chatter, chirp, bark, growl, squeak, and squeal.

Squirrels can be very quiet, especially when enemies are near: owls, hawks, bobcats, badgers, coyotes, raccoons, weasels, skunks, foxes, dogs, cats, and humans.

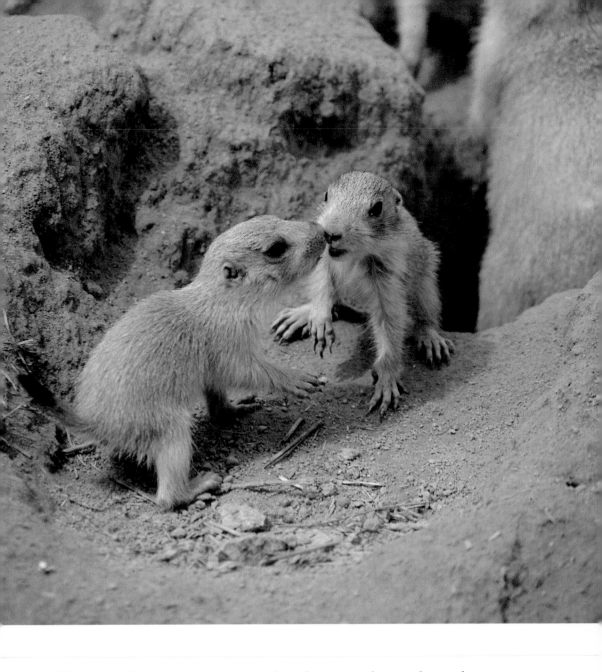

Squirrel eyes are set high on their heads, so they can see in almost any direction.

Squirrels greet each other by touching noses.

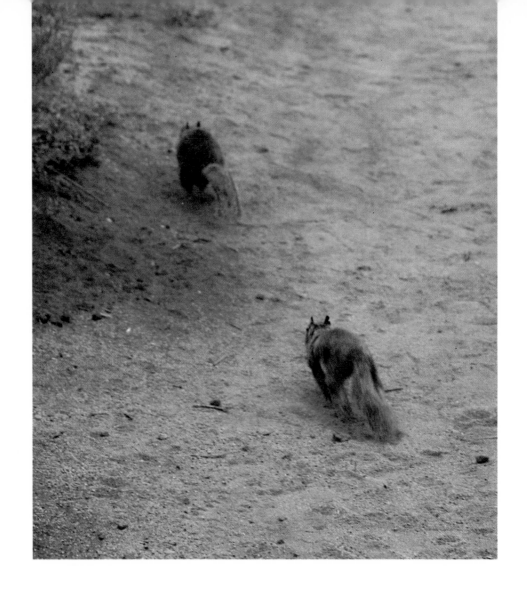

Most squirrels mate in early spring, after much fighting and chasing.

Four to six weeks later, the half-ounce, four-inch-long babies are born in burrows or in tree nests.

There are three to five baby tree-type squirrels or three to ten baby ground-type squirrels.

Blind, hairless, and helpless, they depend on the mother's milk for food. In about six weeks they emerge from the nest, fully furred, bright-eyed, and half the size of the adults.

Baby California ground squirrel

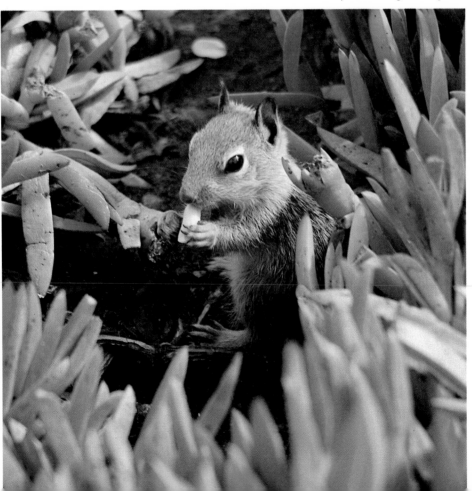

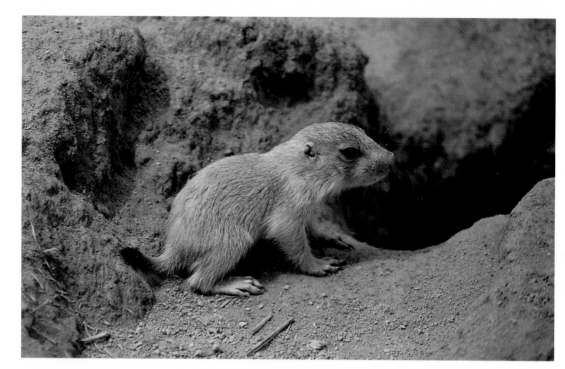

Baby prairie dog

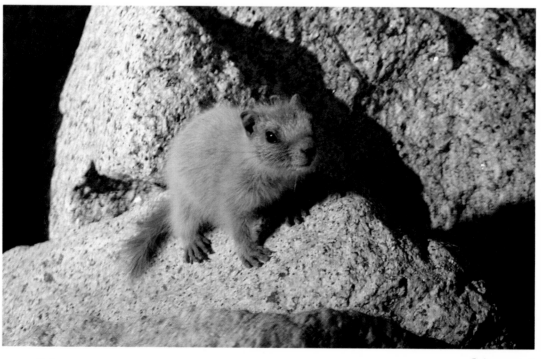

Baby marmot

Baby squirrels are playful and pester the adults.

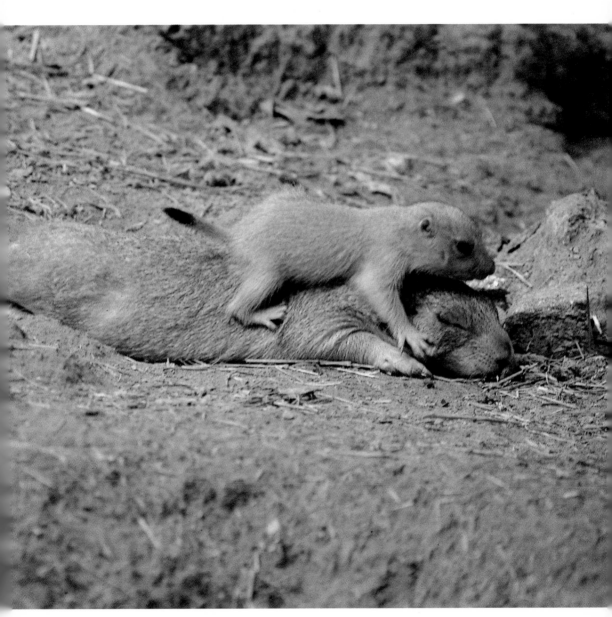

Squirrels have four sharp claws on their front feet and five on the rear. They are used for climbing, digging, and eating.

Every year squirrels shed their fur, called *molting*. They get a heavier coat for winter and a lighter one for summer.

The scientific family name for squirrels is Sciuridae, meaning "shade tail."

Some squirrel tails are large and serve as sunshades on sunny days—and umbrellas on rainy ones.

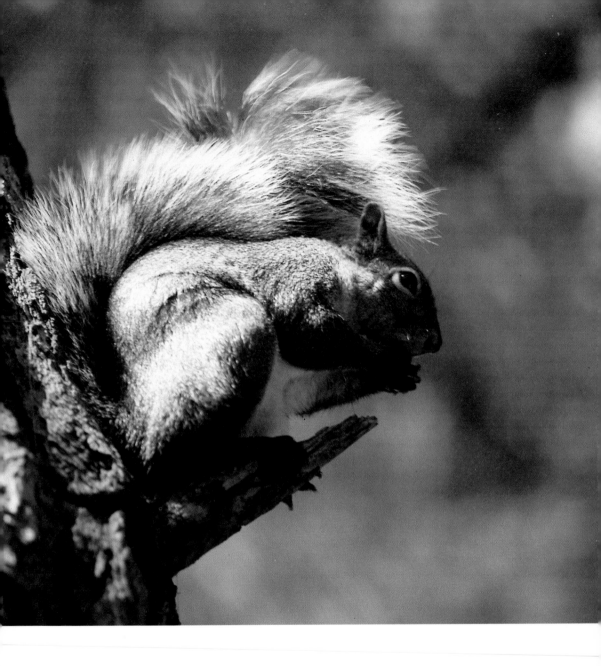

Squirrel tails can be warm blankets, and
help the animals balance when running and
jumping.

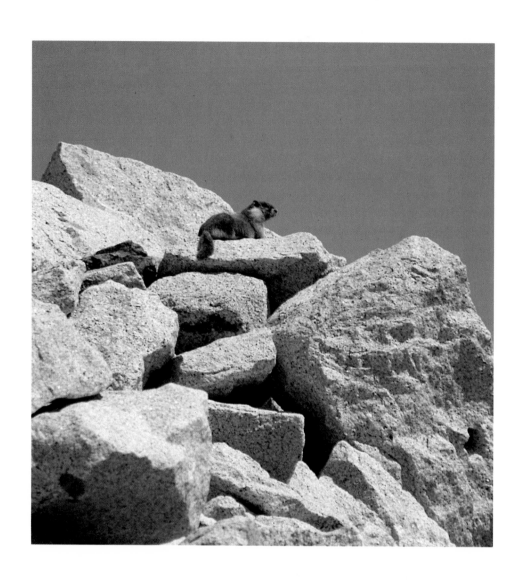

Squirrels often sun themselves on a tree branch, on a rock, or by a burrow.
This alert marmot watches for enemies while sunning.

Not everyone likes the busy squirrels. They sometimes eat the farmers' crops, strip bark from trees, steal seed out of bird feeders, and gnaw on electric wires.

But many of the nuts squirrels bury grow into new trees, which helps to replant our forests.

Squirrels have active days. But by dusk, as day turns to night, only the flying squirrels are up and about.
The other tree squirrels are curled up in their tree nests, and the ground squirrels are curled up in their burrows.

Good night,
busy squirrels,
good night.

Index

3 9004 03021849 6

AFY8097

EDUCATION